CHANGE
YOUR LIFE
ONE
DOODLE
AT A TIME

My furry studio mates

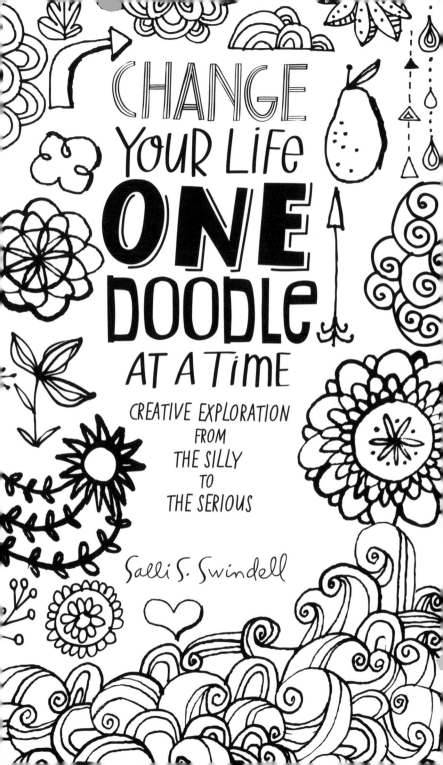

CHANGE
YOUR LIFE
ONE
DOODLE
AT A TIME

CREATIVE EXPLORATION
FROM
THE SILLY
TO
THE SERIOUS

Salli S. Swindell

First published in the United States of America in 2015 by
Quarry Books, a member of
Quarto Publishing Group USA Inc.
100 Cummings Center
Suite 406-L
Beverly, Massachusetts 01915-6101
Telephone: (978) 282-9590
Fax: (978) 283-2742
www.QuartoKnows.com
Visit our blogs at QuartoKnows.com

10 9 8 7 6 5 4 3 2 1

ISBN: 978-1-63159-087-0

Design: Kathie Alexander

Printed in China

This book is dedicated to my two smart, funny, creative boys—Sam and Lee. They continue to change my life for the better every single day!

INTRODUCTION

Welcome!

Being comfortable is so, well, *comfortable!*
We all love our routines. We love familiarity.
We like to know what to expect.
And that's all well and good.
But, that is not what this book is about.

This book is about change. C-H-A-N-G-E!
What is change?
Change is excitement.
Change is surprise.
Change is progress.
Change is the thrill that comes from something new.
THAT is what this book is about.
It's about changing your life one doodle at a time.

Why just one doodle at a time, you ask?

Because, change can be scary.
Change can be daunting! That's where this little book
comes in handy. Because, the truth is, change can be GREAT!

This book is about celebrating and embracing
change—and how the silliest and seemingly smallest
of changes can make a big difference.
For example, you might change your lipstick.
That makes you smile and feel a little more sparkly—
and good things happen when we smile more!
Your smile makes others happy and then they smile more,
and on it goes.

We certainly can't change everything,
but we can always change something,
even a little bit at a time—
one doodle at a time.
This book was created to make change
fun and to open your mind to new ideas,
both big and small.
You will be inspired to think about all kinds of ways to change.
Use this book to make lists, capture your thoughts,
practice your drawing, and test out your ideas.
Doodle, draw, and design your way
through the pages and, by the end of the book,
you will be a changed person.

Start drawing and doodling and see what
surprises are ahead of you!

—Enjoy!

Here's a little warm up!

Draw and doodle your name in lots of
different styles. Try making bubble letters,
decorative initials, and dimensional letters.
Be imaginative and change
up your writing style.

CHANGE YOUR MOOD

What is your mood right now?

Draw some things that make you happy.

List some healthy ways to blow off steam.

 Describe the color of your room.

What color makes you feel happy?
Sleepy? Energized?

Draw things in nature that are your favorite color.

Draw a portrait of your favorite musician.

Create a pattern of musical instruments.

 Put on some of your favorite music
and just draw!

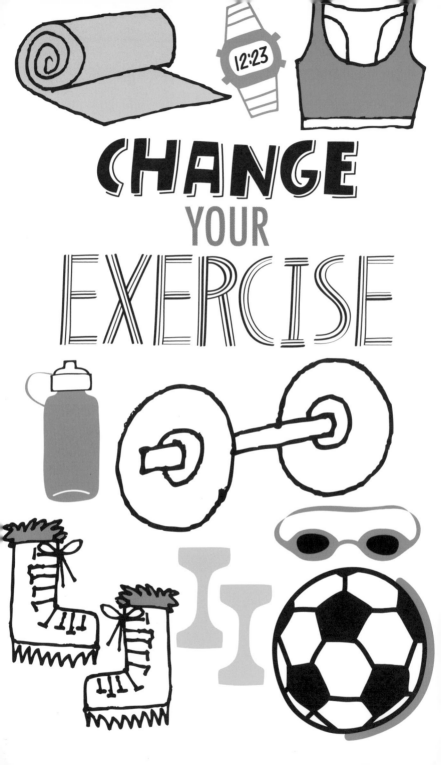

What do you do for exercise now?

Draw any specific equipment or exercise clothing you like to wear.

What other kinds of exercise interest you? Try drawing them.

CHANGE
IS IN THE
AIR

Describe how you feel when change
is about to happen.

Draw a pattern of wind swirls.

Draw a creature that senses changes in the weather.

What is one of the hardest things for you to change?

Try drawing a bicycle—
they are not as challenging as you might think!

Draw your favorite kind of weather—
that's one thing we can't control!

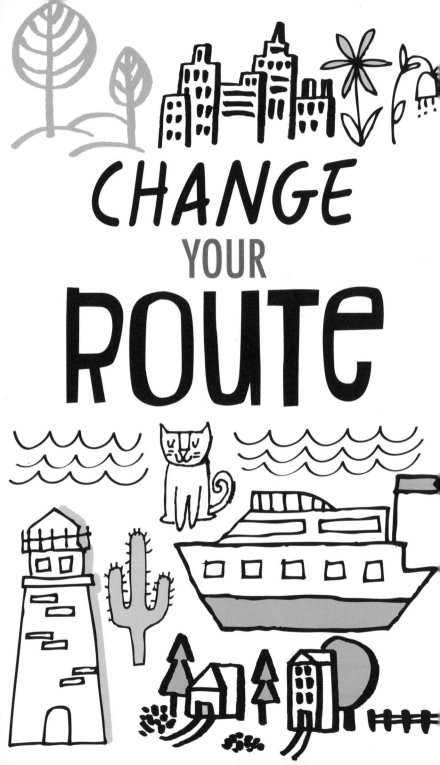

CHANGE YOUR ROUTE

What do you see along your route to work?

Draw some things you would like to see.

Write down another route for a change of scenery.

Look around and describe how one thing changes another.

Cold temperatures change water to snow.
Draw a flurry of snowflakes!

Decoratively illustrate the name of one person who has influenced you in a positive way.

CHANGE
YOUR
UNDIES

Feeling frumpy?
Wear your fanciest pair and draw them here!

Draw a super-fun pattern for your underwear.

Design your ultimate pair of undies.

CHANGE
YOUR
PLAYLIST

What are some of your favorite lyrics?

Draw some musical instruments—
banjos are really fun to draw!

Make a list of some new kinds of
music to add to your playlist.

CHANGE
YOUR
DIET

What would be your perfect menu?

Draw some foods you've never tried.

Draw the foods that give you energy.

31

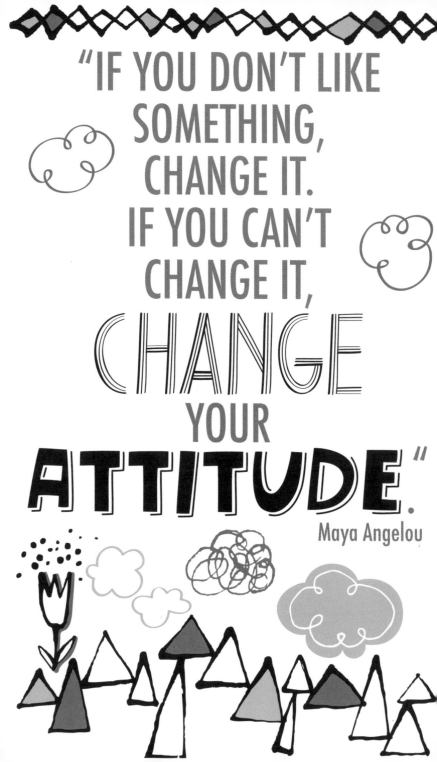

"IF YOU DON'T LIKE SOMETHING, CHANGE IT. IF YOU CAN'T CHANGE IT, CHANGE YOUR ATTITUDE."

Maya Angelou

 Decoratively illustrate a positive phrase.

Make a pattern of things that make you smile!

Draw a series of clouds.

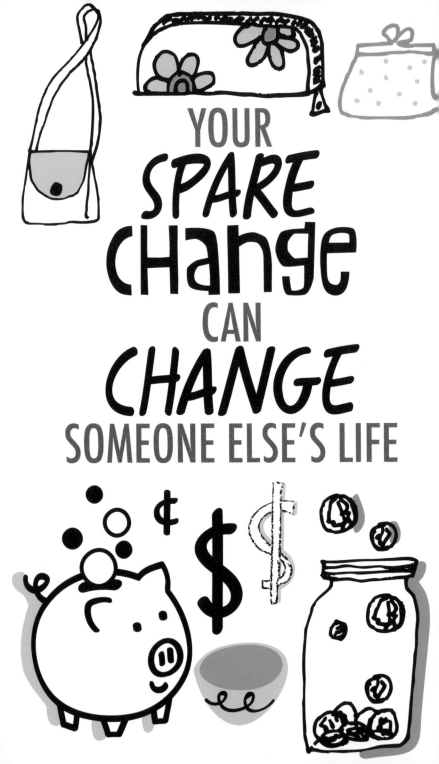

Draw the places or containers where
you leave your loose change.

Design a sweet little change purse.

Draw an icon for a charity or organization where
you like to donate your spare change.

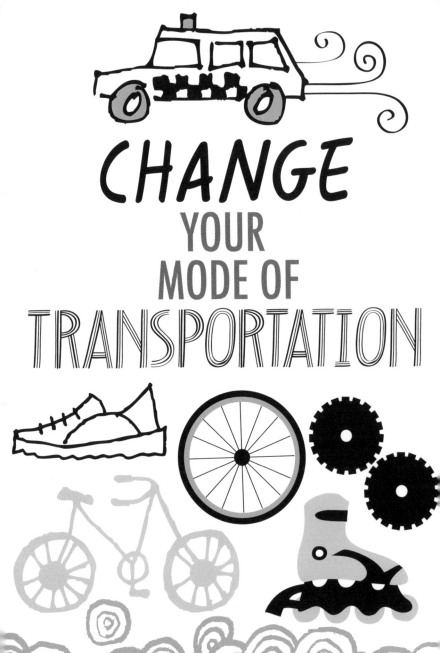

CHANGE YOUR MODE OF TRANSPORTATION

How do you get around now?

Draw your favorite mode of transportation.

Design a pattern of gears and wheels.

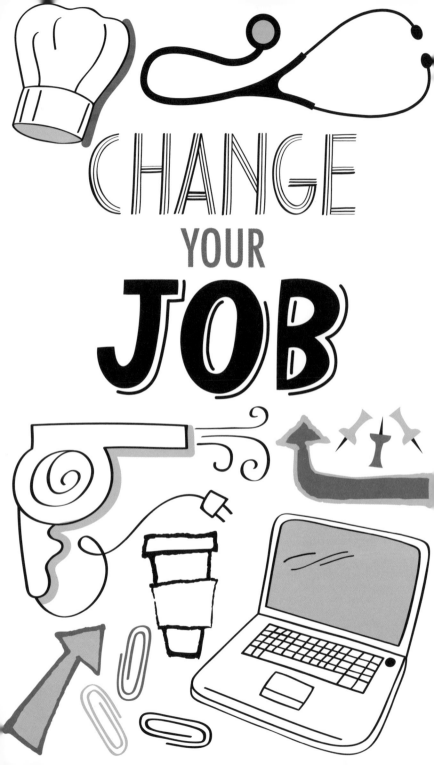

CHANGE
YOUR
JOB

Draw how you feel when you're working.

Draw some things that are part of your workplace.

Write down three other jobs that interest you.

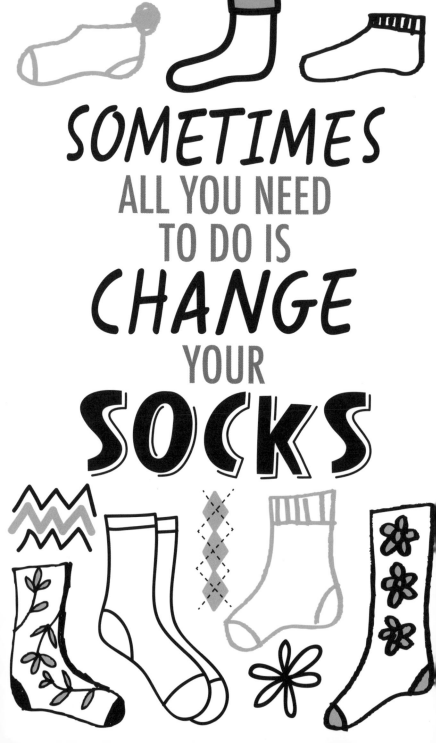

SOMETIMES
ALL YOU NEED
TO DO IS
CHANGE
YOUR
SOCKS

Draw your favorite pair of socks.

Design a cool pattern for your socks.

Create a pattern with all kinds of socks!

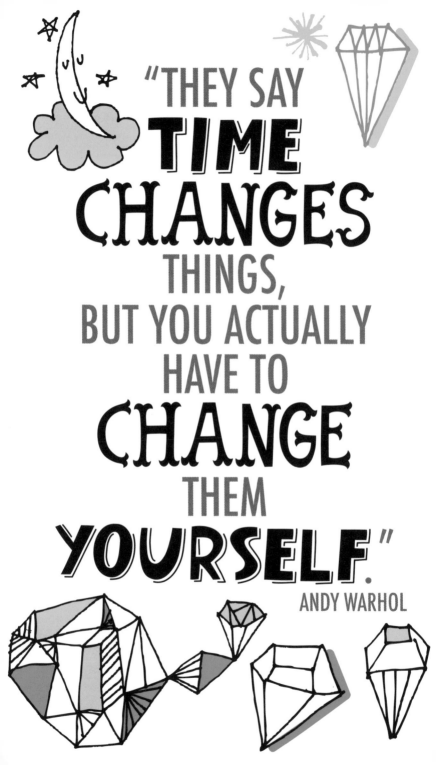

"THEY SAY **TIME** CHANGES THINGS, BUT YOU ACTUALLY HAVE TO **CHANGE** THEM **YOURSELF.**"

ANDY WARHOL

Draw a recent dream you had.

Tape two pencils together and draw something!

Draw in the dark.

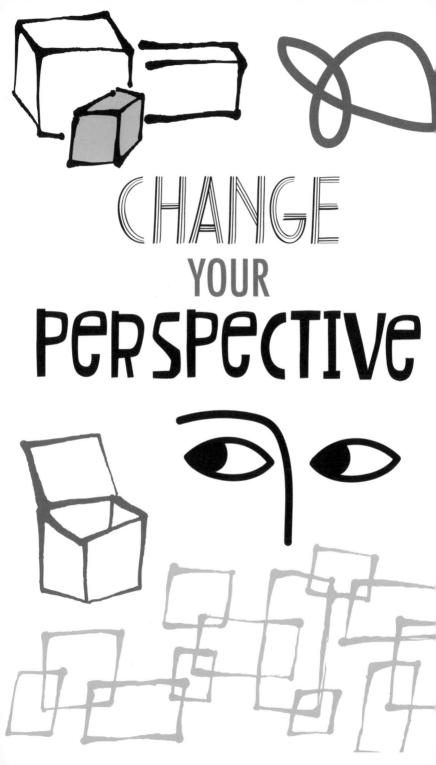

CHANGE YOUR PERSPECTIVE

Are you flexible and open
to new ideas?

Draw a box from three different angles.

Look at the doodle below. What do you see?
Add on to the drawing to create something new.

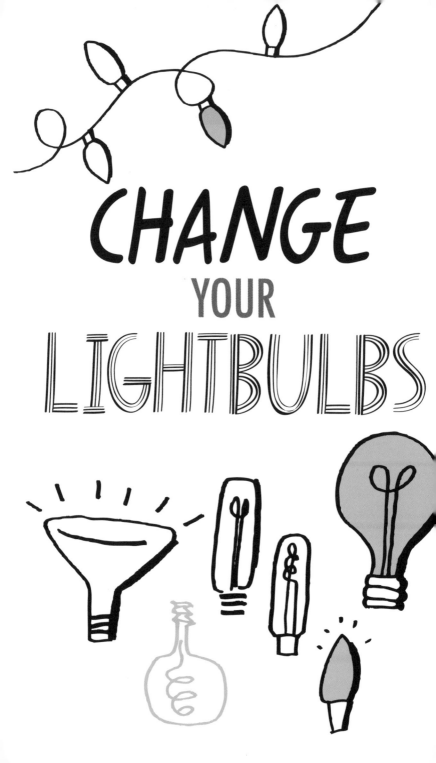

CHANGE
YOUR
LIGHTBULBS

Draw or write about some things that
light up your life.

Draw some things that brighten your day.

What bright ideas have you
had recently?

CHANGE
YOUR
HAIRSTYLE

 Draw the different hairstyles
you've had over the years.

Draw yourself with the hairstyle
of your favorite celebrity.

Design a pattern of hair accessories such as
barrettes, brushes, and combs.

Draw a silhouette of your head and fill in the things that are always on your mind.

Create a design of word balloons with thoughtful words.

What are some books you've read that have changed your perspective?

Draw three things that represent
your morning routine.

How can you easily change your day around?

Draw something you eat for breakfast
that you might want to eat for dinner instead.

Draw or write about a change you
have no control over.

What changes will you make this year?

Get used to change
by illustrating the word
three different ways.

HAVE YOU EVER HAD A **KISS** THAT HAS CHANGED YOUR **LIFE ?**

Yes? Draw the details please!

Doodle some sparkly kisses.

Illustrate the word "kiss" in a decorative style.

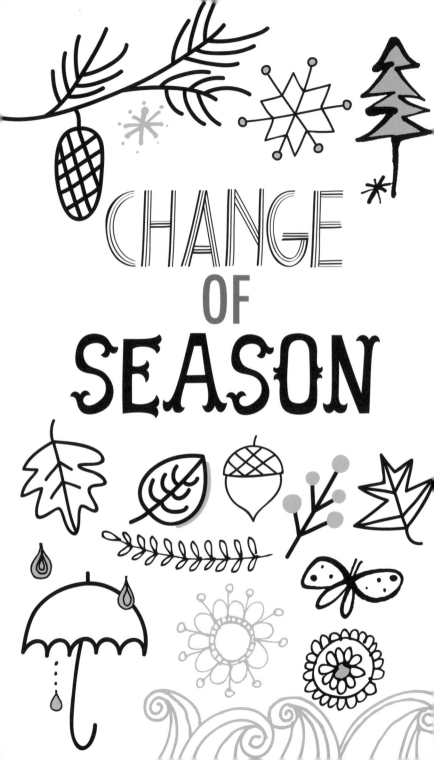

CHANGE
OF
SEASON

Draw some special things from each season.

What season is your favorite?

Design a fun seasonal pattern!

CHANGE THE CHANNEL

Re-create a scene from your favorite movie or show.

Draw some of your favorite actors or actresses.

 Think of a different
channel to watch.

"YOUR LIFE DOES NOT GET BETTER BY **CHANCE** IT GETS BETTER BY **CHANGE.**"

JIM ROHN

Write down three things you'd like
to change this week.

Start by changing up your morning
beverage and draw it here.

Smile more and see how it changes things.

Design a cool pattern for
your bed linens.

Draw some feathers for your pillow.

Draw three things that
help you relax.

What words do you
tend to overuse?

Learn a new word every day and illustrate it!

Do you have a favorite word? Draw it!

CHANGE
YOUR
PHONE CASE

Illustrate a word or phrase that
will make your phone case an inspiration
every day.

Make a custom design for your phone case.

Design an icon for your phone case that
best fits your personality.

CHANGE OF SCENERY

Look out your window and draw some things you see.

Draw a few things that remind you
of a fun place you've traveled.

Draw a city skyline, a garden, and a beach.

CHANGE
IS AN
ADVENTURE

What's the most adventurous thing you've ever done?

Draw a place you are yearning to visit.

 Illustrate the word "adventure"
using a different style for each letter.

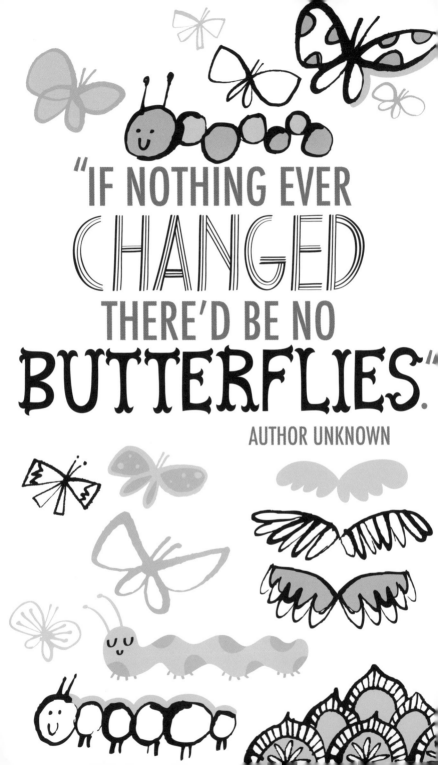

"IF NOTHING EVER CHANGED THERE'D BE NO BUTTERFLIES."

AUTHOR UNKNOWN

Doodle some fun, squiggly caterpillars.

Create a pattern of wings.

Draw the four stages of a butterfly:
egg, caterpillar, chrysalis, and butterfly!

"THERE IS NOTHING PERMANENT EXCEPT CHANGE."

Heraclitus

Draw the stages of a growing plant.

Draw what you think the bottom
of the ocean looks like.

Try and draw the exact same thing
three times and see how it changes.

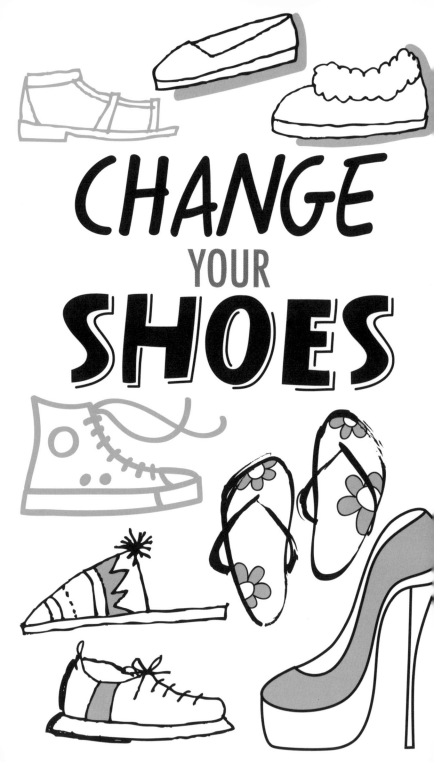

CHANGE

YOUR

SHOES

Design the perfect shoe!

Draw your favorite shoe styles.

What shoes make your feet feel the comfiest?

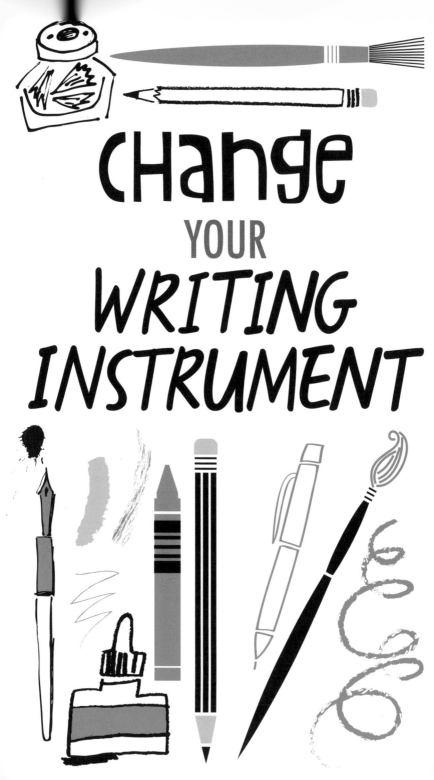

CHANGE
YOUR
WRITING
INSTRUMENT

Draw all of the pens, pencils, and markers you use when doodling.

Try drawing an ink pen and bottle of ink.

Create a fun pattern of paintbrushes.

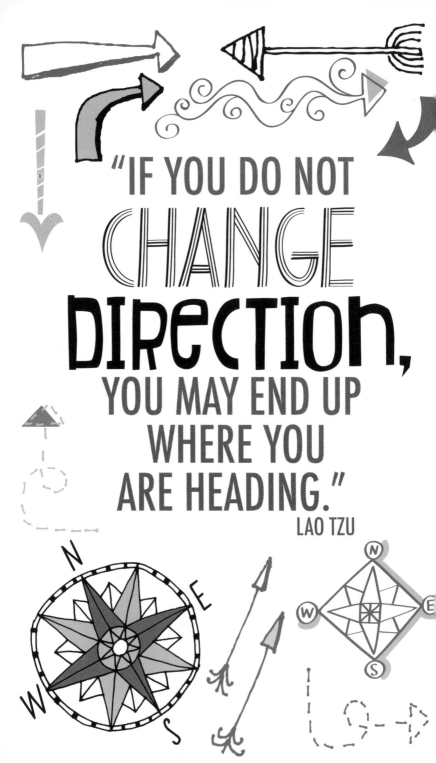

Do you feel like you are headed in the right direction?

Make a pattern of decorative arrows.

Draw a compass that reflects your style.

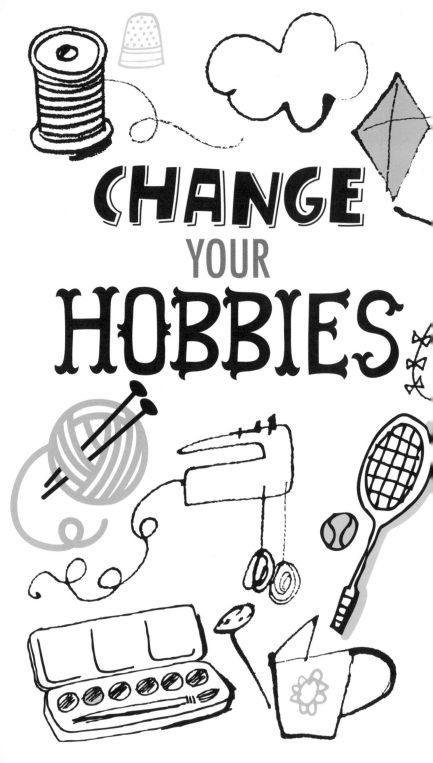

CHANGE
YOUR
HOBBIES

What is your favorite pastime?

Design a pattern using the icons
that represent your hobbies.

Draw some new things to try,
like knitting or gardening!

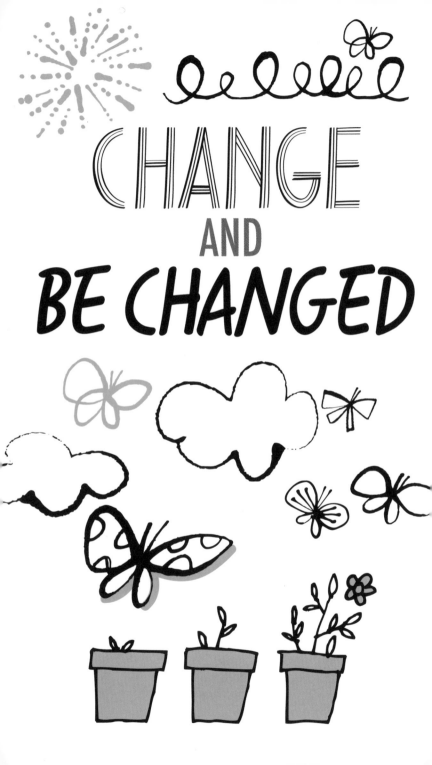

CHANGE

AND

BE CHANGED

Describe an event that has changed your life for the better.

Draw something in three stages of change.

Create a pattern of butterflies!

"YOU MUST BE THE CHANGE YOU WISH TO SEE IN THE WORLD."

MAHATMA GANDHI

 Write down three ways you
can make a positive change today.

Illustrate the word "smile."

Make a pattern of things that make you happy.

CHANGE OF HEART

Draw a happy heart!

What is your heart's desire?

Design a lovely heart pattern.

CHANGE
YOUR
PACE

Are you always rushing around,
or do you take your time and enjoy things?

Draw a pattern of clocks.

Decoratively illustrate the word
"breathe" as a reminder to relax!

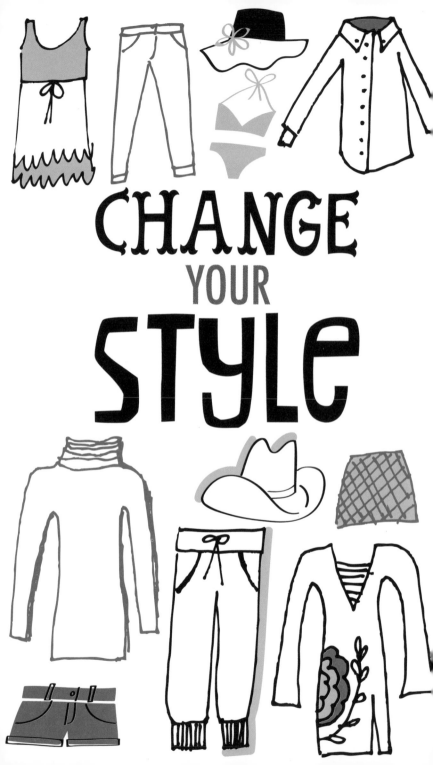

CHANGE
YOUR
STYLE